LOUISA MATTHIASDOTTIR

SMALL PAINTINGS

Mi bien cara (I hope this is Spanish. I can't
find my dictionary) Nuria,

This is something I love. I hope you
do, too. And it reminds me of you, and your
video. It is to say admiring congratulations
on your video and for being such a fine
artist (and wonderful story teller!), and
to thank you for the gift of our
friendship, with love.

Jennifer

May 1987

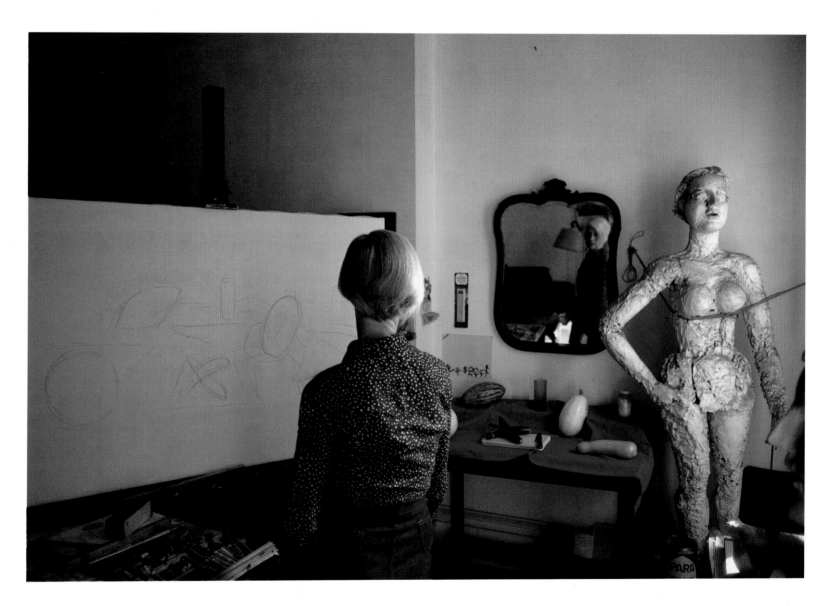

LOUISA MATTHIASDOTTIR
IN HER STUDIO

LOUISA MATTHIASDOTTIR

SMALL PAINTINGS

HUDSON HILLS PRESS

NEW YORK

First Edition

© 1986 by Martin S. Ackerman

Published in the United States by Hudson Hills Press, Inc.,
Suite 1308, 230 Fifth Avenue, New York, NY 10001-7704.

Distributed in the United States, its territories and possessions, Mexico,
 and Central and South America by Rizzoli International Publications, Inc.
Distributed in Canada by Irwin Publishing Inc.
Distributed in the United Kingdom, Eire, Europe, Israel,
 and the Middle East by Phaidon Press Limited.
Distributed in Japan by Yohan (Western Publications Distribution Agency).

Editor and Publisher: Paul Anbinder
Copy editor: Eve Sinaiko
Designer: Marjorie Merena, in association with Orion Book Services
Composition: American–Stratford Graphic Services, Inc.
Manufactured in Japan by Toppan Printing Company

Library of Congress Cataloguing-in-Publication Data

 Perl, Jed, 1951–
 Louisa Matthiasdottir, small paintings.

 Bibliography: p.
 1. Matthiasdottir, Louisa—Catalogues.
 2. Matthiasdottir, Louisa—Criticism and interpretation.
 3. Iceland in art—Catalogues.
 4. Small painting—20th century—United States—Catalogues.
 I. Rosenthal, Deborah. II. Weber, Nicholas Fox, 1947- . III. Title.
 ND753.M38A4 1986 759.9591'2 86-10577
 ISBN 0-933920-66-0 (acid-free paper)

Photo credits
 Páll Stefánsson: frontispiece
 eeva-inkeri: plates 1, 2, 4, 6–9, 11–18, 20–22, 24–30, 32–35, 37–39, 41, 42
 Leifur/Myndidn: plates 3, 10, 19, 23, 31, 36, 40
 Jacob Burckhardt: plate 5
 Alexander Wallace: plate 43

This book is made possible with the generous assistance of the Martin S. Ackerman Foundation.

CONTENTS

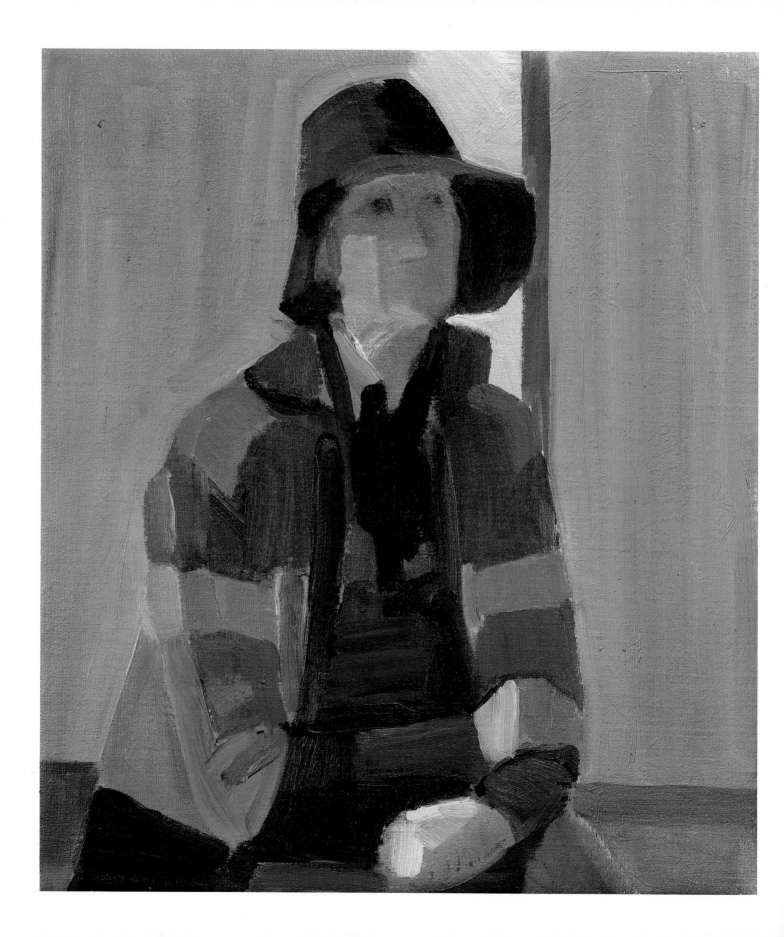

LOUISA MATTHIASDOTTIR first came to America from her native Iceland in 1943, at the age of twenty-five. She now lives in New York, but she has often returned to Reykjavik, and paintings emerge from her sojourns in both places. At home in New York, Matthiasdottir seems uninterested in painting the terrain outside the walls of her studio: her New York subjects are self-portrait and still life. Bits of New York life do find their way into the still lifes, in the form of Chinese eggplants, honeydew melons, and other produce collected on her sorties to Manhattan markets. But for Matthiasdottir, Iceland's hills, towns, and coastline—whether she paints them from life or recomposes them back in New York—remain the essential landscape: a brightly colored world drawn from a well of childhood memories.

Matthiasdottir has remained rooted in her homeland, in an art-loving family that bought the work of Icelandic artists, and she has also put down roots in New York. When she left Iceland to study, she went first to Denmark and then, as did so many others, to Paris. The onset of World War II brought her to New York, where she met painters (including Hans Hofmann, with whom she studied) who understood Fauvism and Cubism and saw Paris as their challenge. The New York representational painters with whom Matthiasdottir began exhibiting at the cooperative Jane Street Gallery after the war—they included Leland Bell, Nell Blaine, Al Kresch, and Hyde Solomon—all had French painting in their blood.

Looking at Matthiasdottir's paintings, one feels that she carries Europe within her. She embraces Chardin's matter-of-factness and Fernand Léger's modernity with ease, even serenity. It is not her way to act shaken to her foundations—as some artists do—by the masters she adores. Matthiasdottir appears unflappable, without nostalgia, in the face of the past. She is not tempted by the perfume of French painting—its arabesques and elegant moves. Instead, she takes the bones—the structure. Her clear colors and unambiguous spaces are the yield of a pragmatist's journey through European painting. There is a frontier bluntness to her way of handling paint.

On the rare occasions when Matthiasdottir speaks of her work, she seems reluctant to explicate a process that is natural to her. Once, describing what she does in her studio, she said, "I'm probably like all other painters; I don't even know what determines the size of a painting. I might go to the easel and think, 'Well, I have only so much time. I'll do a little painting.' Or I'll decide I have a lot of time and then do a large one. It's as simple as that." Whether working on a large or small canvas, Matthiasdottir paints quickly and often finishes a picture in one session. Her commitment to reality is so strong that she must make a complete re-creation of the subject each time she paints. In none of her paintings does one see the world coming into being; it is always there, entire.

LOUISA MATTHIASDOTTIR

Jed Perl and
Deborah Rosenthal

PLATE 1 | SELF-PORTRAIT 1980

oil on canvas 16 × 14 inches

Walking through a Matthiasdottir exhibition, one is affected first by the brilliance of her palette: her cobalts, ultramarines, cadmiums, and alizarins leap to the eye and bring with them the powerful presence of the objects they describe. From painting to painting she invokes a variety of moods: the sharp familiarity of at-homeness in the still lifes, the poignancy of figures and animals in the faraway places of the landscapes, and the enigma of the artist herself, seen but not quite revealed in the self-portraits. Matthiasdottir's treatments of various subjects complement one another, and when her pictures are seen together in all their profusion they form a special kind of harmony.

Matthiasdottir's large, simple structures often build within the pictures a world with the intensity of an emblem. Her self-portraits recall Renaissance and Mannerist portraiture in the way they convey the force of her personality through the suppressed and conventionalized attitude of the figure. Some of her images are so generalized as to verge on the symbolic. In the landscapes the pairing of a black and a white sheep, the centering of a pony in a composition, the arrangement of a mother animal with her young—all are like heraldic devices, crossing over at times into allegory. Buildings, when they appear in the landscapes, seem conjured up for the occasion, as clear and neat as the visions of little towns in Trecento paintings. The landscape pictures that pit a lonely house or two against the unbroken coastline, or a figure against a deserted street, owe their meaning to the great Romantic dichotomy of nature and the man-made.

Matthiasdottir's small paintings, of which this book presents a selection, reflect the full range of her concerns. Some artists—Pablo Picasso, for instance, in the 1928 Dinard bather paintings, or André Derain in his late, "Pompeian" phase—use a small format to create miniaturized, toy worlds. Such paintings are playful, and they invite us to share a fantasy—the fantasy of a world tiny enough to hold in one's hand. Though one feels some of that kind of intimacy in Matthiasdottir's small paintings, they can hardly be described as delicate or whimsical. These small pictures have the same large attack, the same bold design as Matthiasdottir's bigger compositions.

In the small landscapes with animals, everything Matthiasdottir has seen is subsumed in the simplest of shapes. In *Ewe with Lambs* (PLATE 2), a triangle of blue water meets a triangle of green hill that in turn silhouettes three brilliantly white, stockily rectangular sheep. All color shapes—from the dash of white cloud in the sky to the slice of red earth in the foreground—exert equal pressure. One doesn't feel that the landscape is a space made to hold the animals: the pictorial elements of color and shape, which have little meaning in and of themselves, achieve their effect almost exclusively through their interaction. They are as tightly plotted and fit-

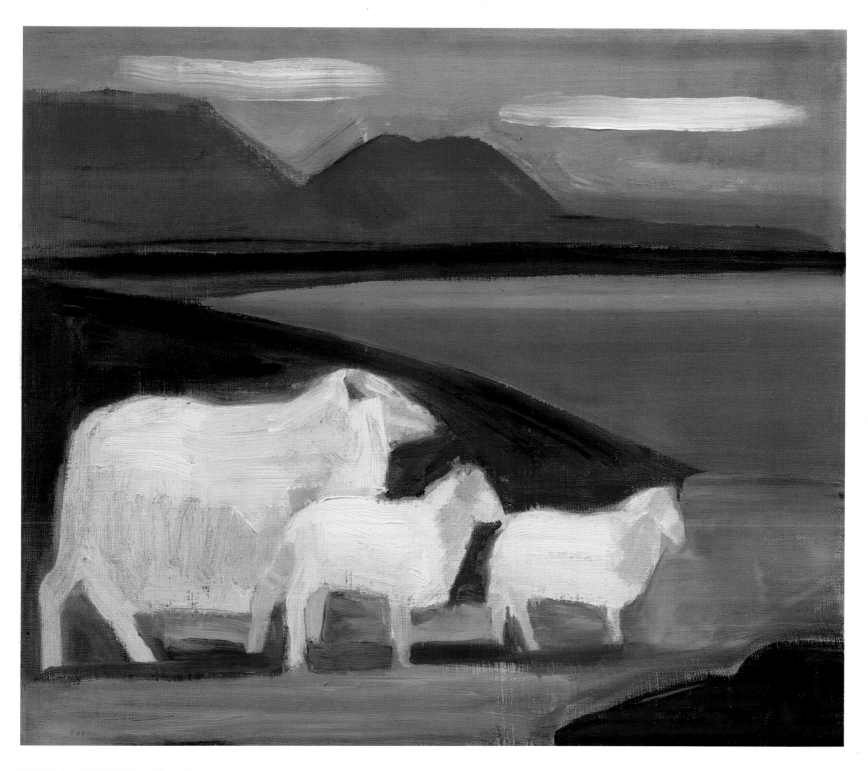

PLATE 2 | EWE WITH LAMBS 1983

oil on canvas ·14 × 17 inches 9

ted together as the color harmonies in a painting by Piet Mondrian, and, like a Mondrian, a Matthiasdottir landscape is seamless: the emotions that arise from the parts cannot be detached from one's apprehension of the whole.

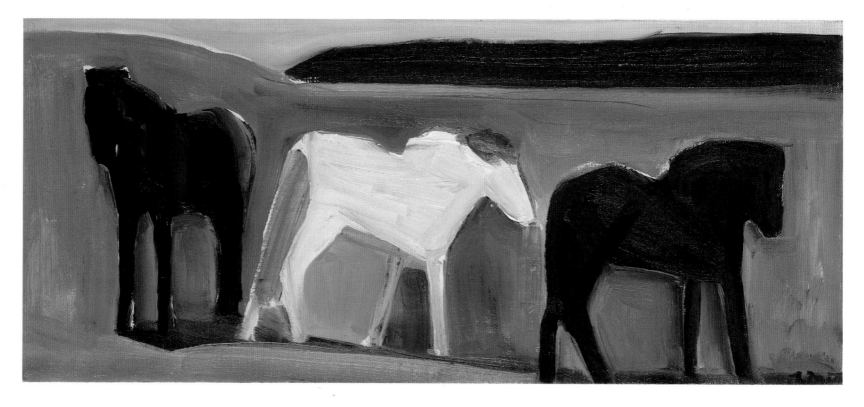

PLATE 3 | THREE HORSES 1984
oil on canvas 9 × 21 inches

In elongated paintings such as *Three Horses* (PLATE 3) and *Horses and Rider* (PLATE 4) Matthiasdottir's small format expands into a shape with friezelike proportions. These pictures, which the eye traverses horizontally, across the surface, put one in mind of the stretched rectangles of Paul Klee and Robert and Sonia Delaunay. They are fragments of an arrested journey in which stationary horses and figures face one another across time and space: little horses stand gravely, quietly; a person looks out at us; a small fable gathers.

More than once, critics have associated Matthiasdottir with the Northern ethos of Edvard Munch and Ferdinand Hodler. Talking to an interviewer about this connection, the painter countered, "Well, I like Matisse, I know that. And Titian. Is that

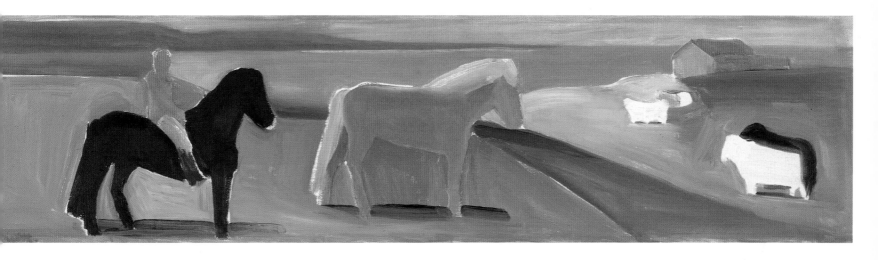

PLATE 4 | HORSES AND RIDER 1984
oil on canvas 10 × 39 inches

enough?" When Matthiasdottir mentions Titian and Henri Matisse, one thinks of painters with an expansive view of the world, and paintings that are calm but intense. There *is* something Northern and melancholy about Matthiasdottir's work, but she is not at odds with the world as Hodler and Munch were. She reconstructs nature on the canvas in order to embrace it, and in this she recalls the great colorists: she puts her faith in color-as-emotion. There is a matter-of-fact side to her presentation of the world that prevents her riot of color from ever seeming excessive. For Matthiasdottir, the everydayness of the subject is a source of freedom.

Matthiasdottir's paintings of three decades ago have the same kinds of subjects, and are painted in much the same way, as her current work. She herself does not distinguish one period from another. She goes into the studio and continues, from painting to painting, year after year with a remarkable constancy. For Matthiasdottir, painting does not change; not only does she understand the fixity of her position, but she also regards it as a strength. Perhaps it is this confidence in her own identity that has enabled Matthiasdottir to immerse herself so fully in the culture of art within and beyond painting. The style of her work—its structure and its surface— has become transparent. By defining herself through her Icelandic hills, huddled sheep, her array of vegetables, and her own face, Matthiasdottir has given us on canvas a world that is her own.

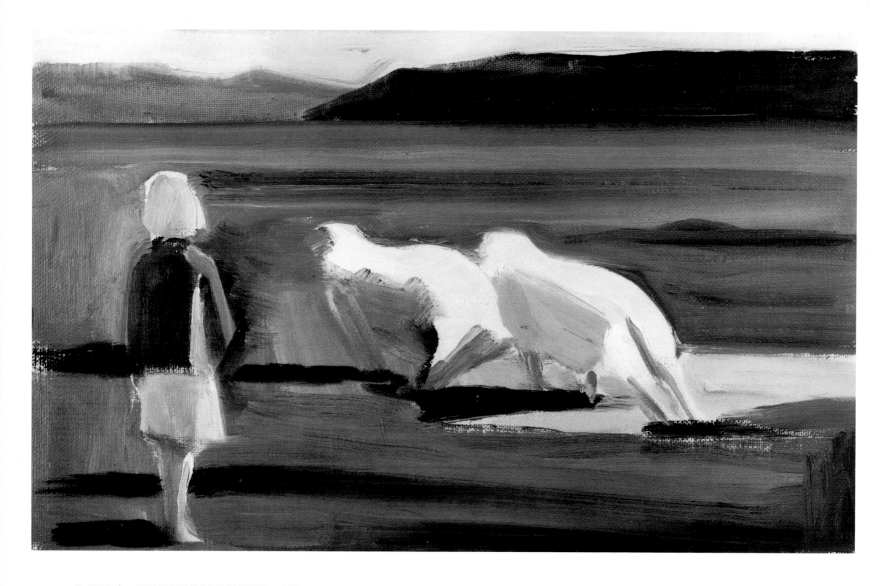

PLATE 5 | GIRL WITH RUNNING SHEEP 1983
oil on canvas 8¾ × 14¼ inches

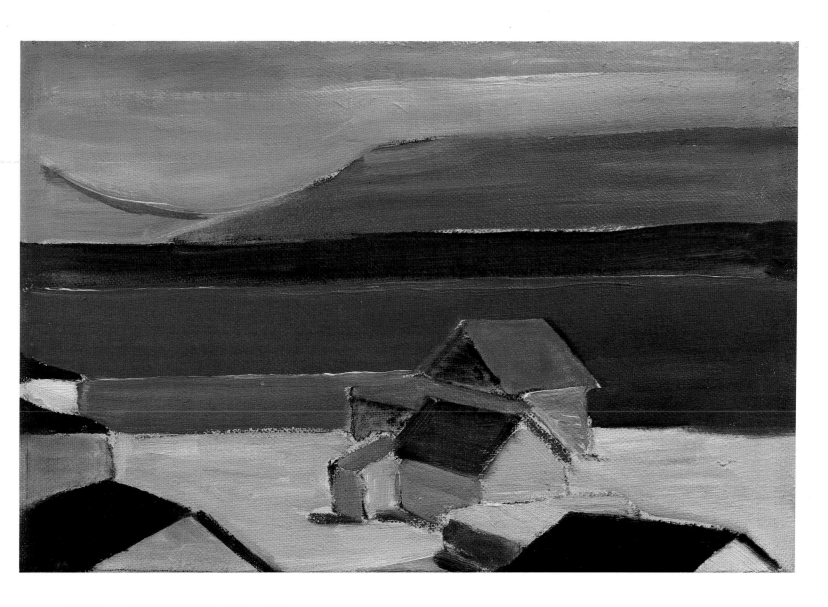

PLATE 6 | GREEN HOUSE, RED ROOF 1982

oil on canvas 8 × 12 inches

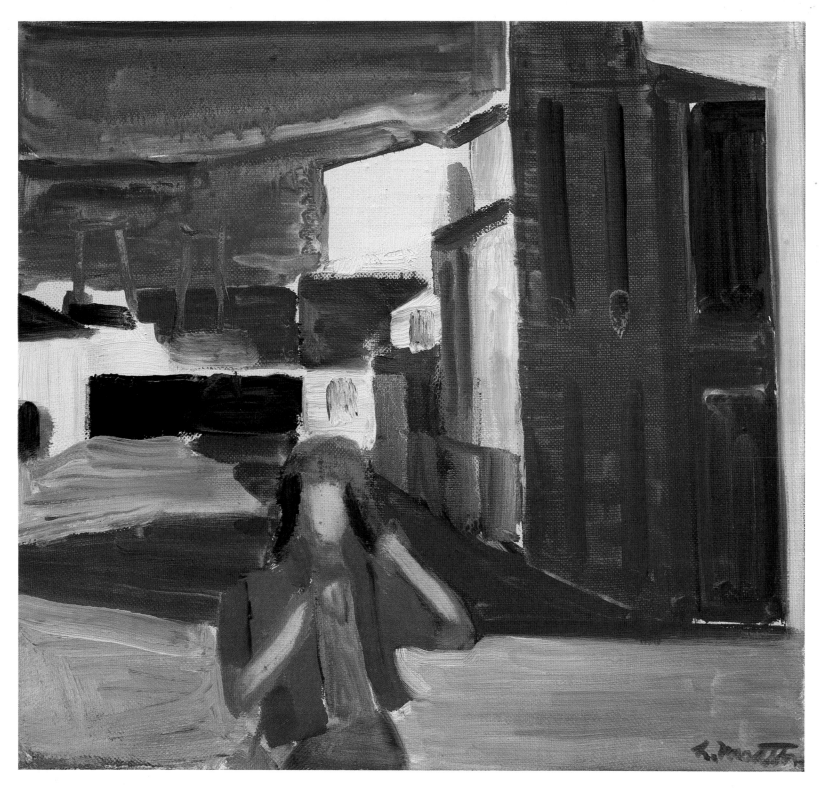

PLATE 7 | AEGISGATA 1980
oil on canvas 10 × 11 inches

14

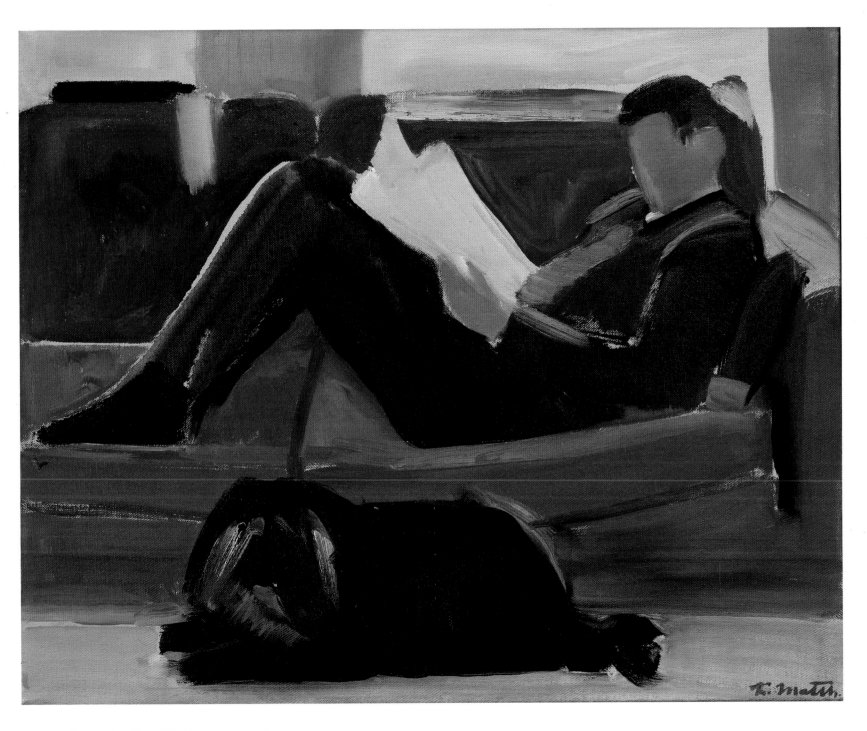

PLATE 8 | FRANK AND MISCHKA 1972
oil on canvas 14 × 18 inches

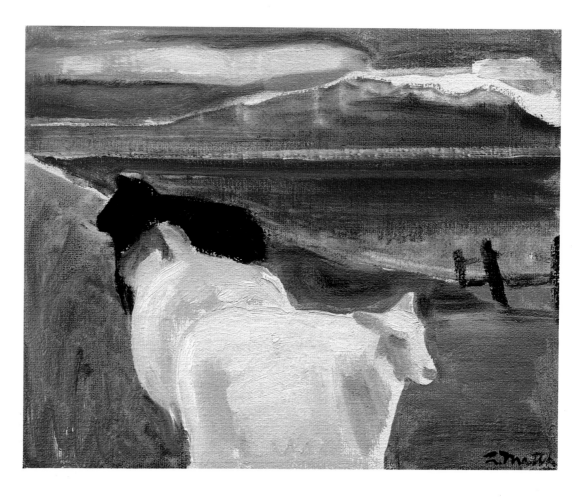

PLATE 9 | SHEEP: TWO WHITE, ONE BLACK 1982
oil on canvas 8 × 10 inches

16

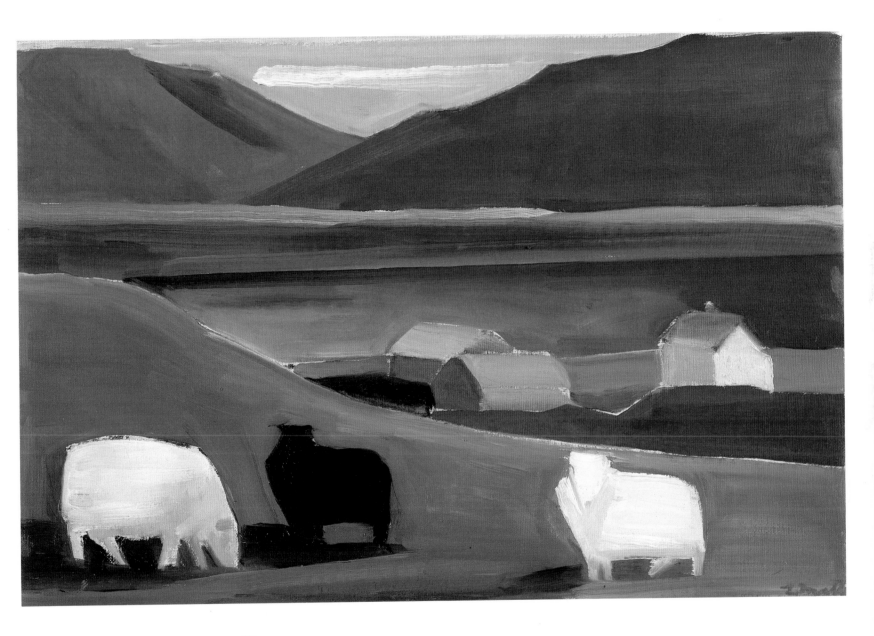

PLATE 10 | HOUSE AND SHEEP 1982

oil on canvas 14 × 21 inches

17

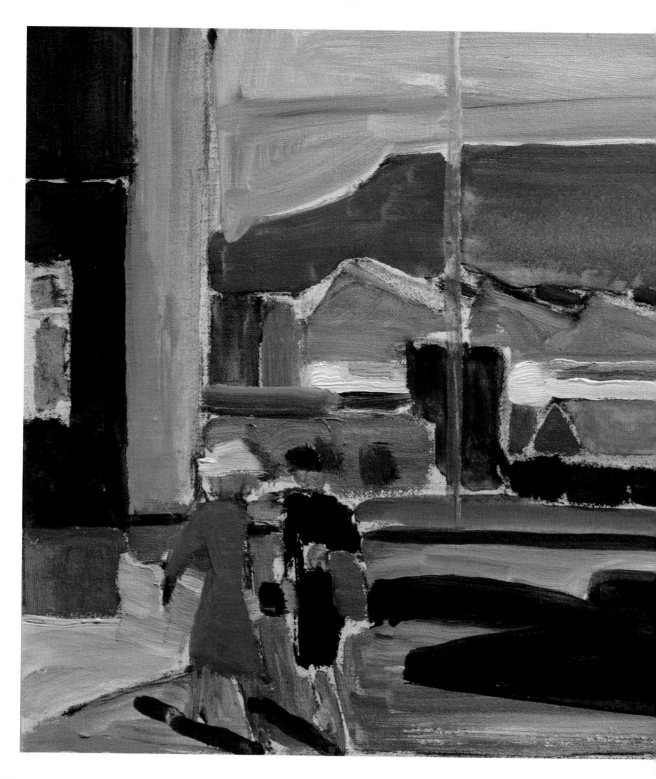

PLATE 11 | VESTURGATA 1980

oil on canvas 9½ × 19 inches

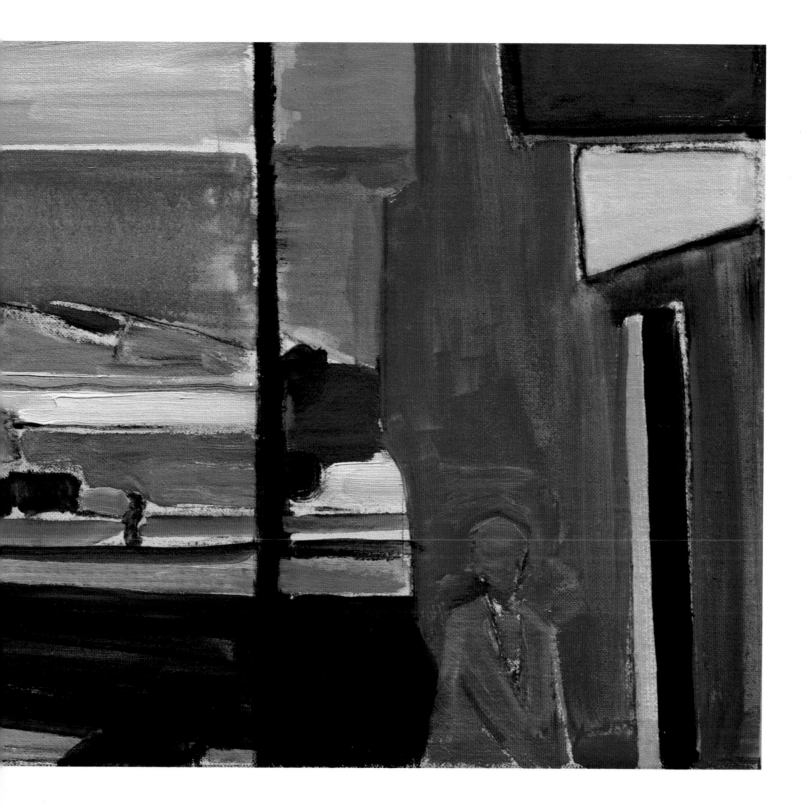

19

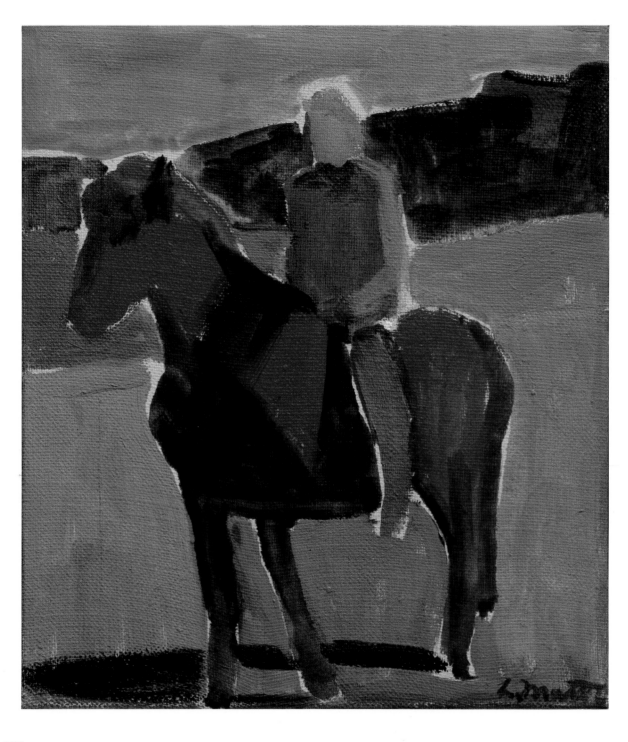

PLATE 12 | GIRL ON HORSEBACK 1980

oil on canvas 9 × 8 inches

20

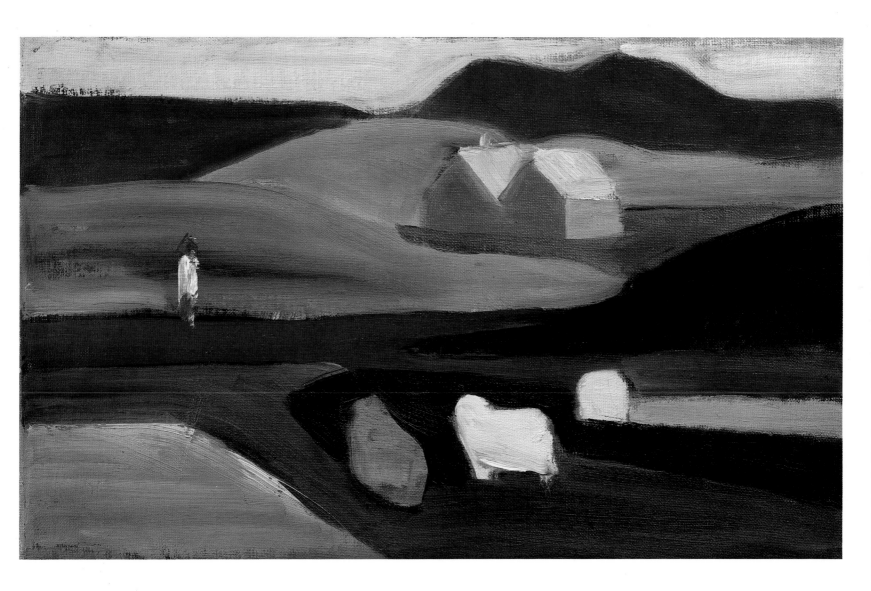

PLATE 13 | FARM 1984
oil on canvas 10 × 16 inches

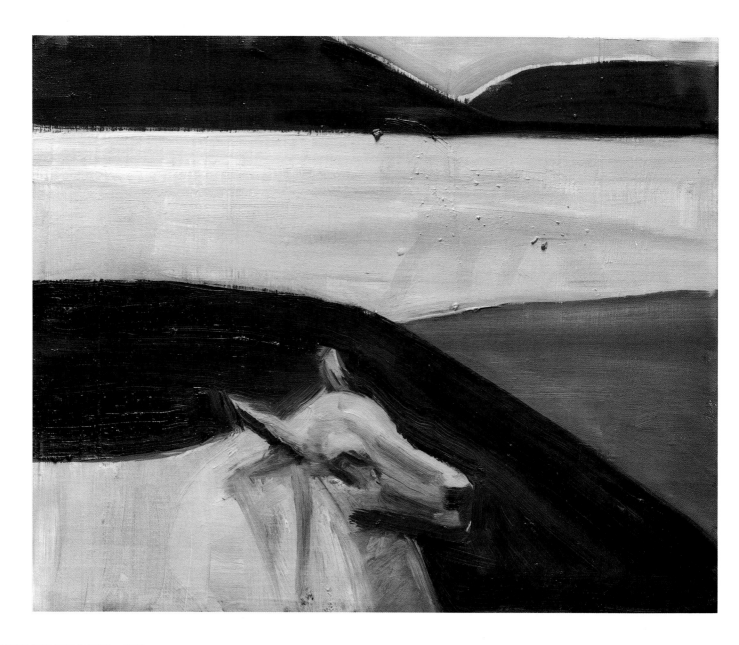

PLATE 14 | SHEEP AND MOUNTAIN 1984
oil on canvas 9 × 12 inches

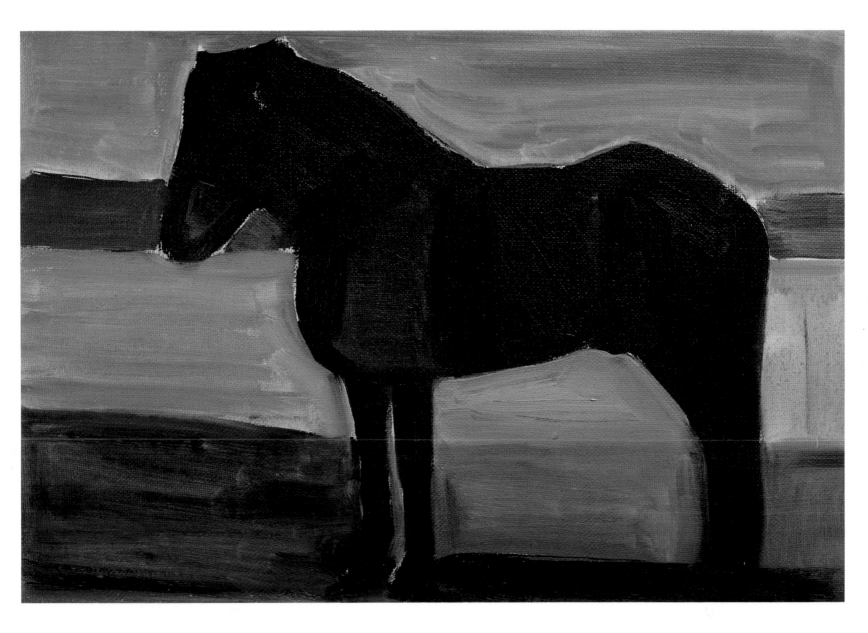

PLATE 15 | HORSE 1978
oil on canvas 9 × 14 inches

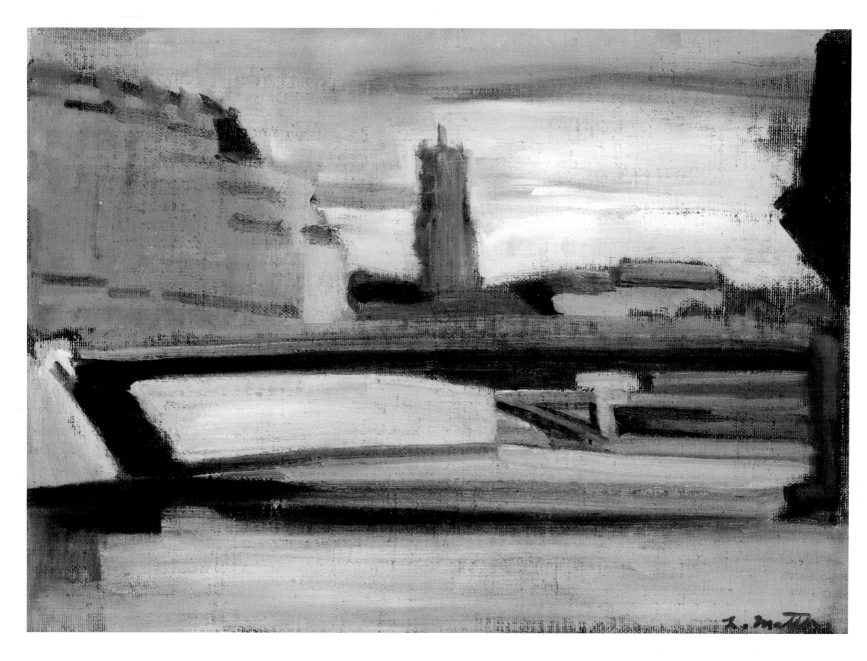

PLATE 16 | PONT ST. LOUIS 1978

oil on canvas 12 × 17 inches

24

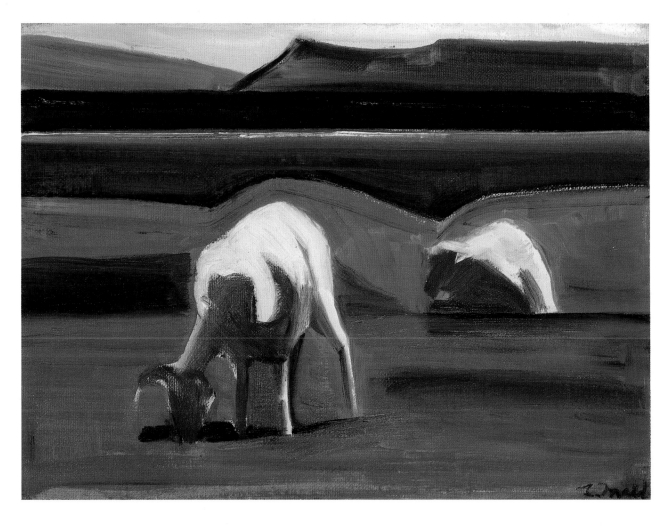

PLATE 17 | TWO SHEEP, BLUE MOUNTAIN 1984

oil on canvas 9 × 13 inches

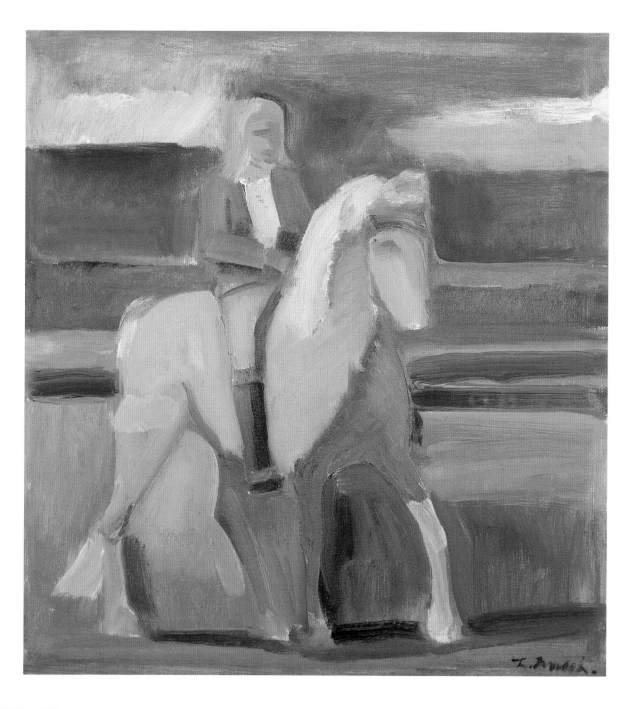

PLATE 18 | HORSE AND RIDER 1976

oil on canvas 14 × 13 inches

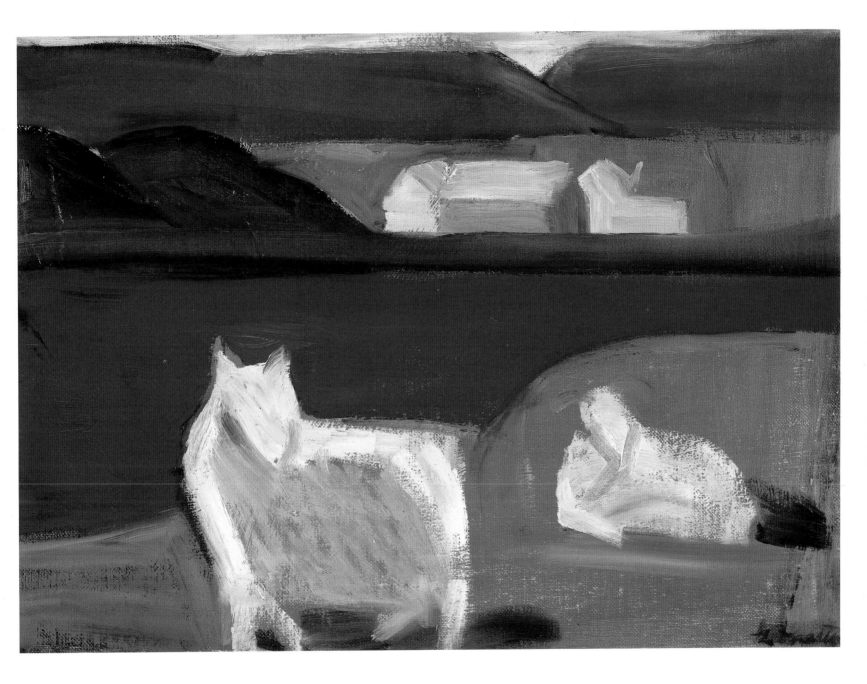

PLATE 19 | HOUSE AND SHEEP 1980
oil on canvas 13 × 18 inches

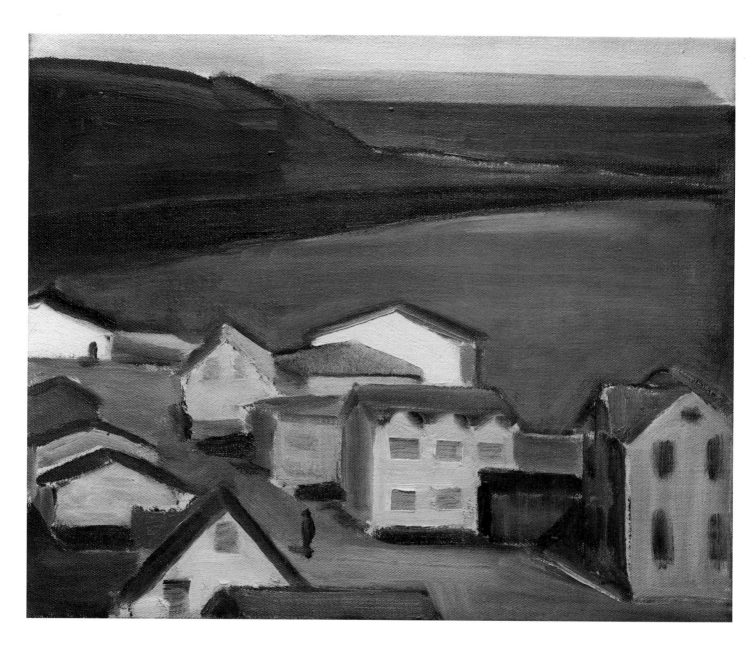

PLATE 20 | VILLAGE 1978

oil on canvas 11 × 14 inches

28

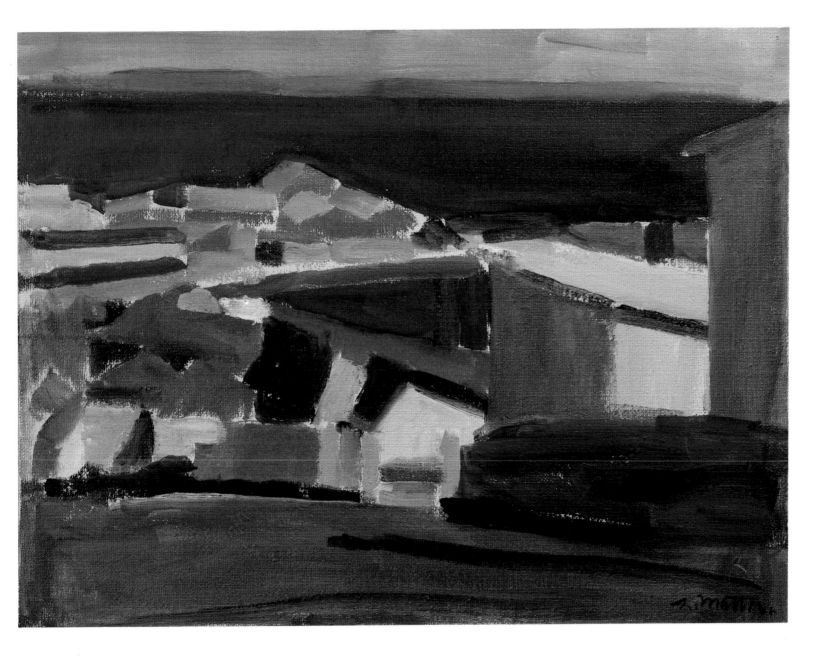

PLATE 21 | OLAFSVIK 1978

oil on canvas 12 × 16 inches

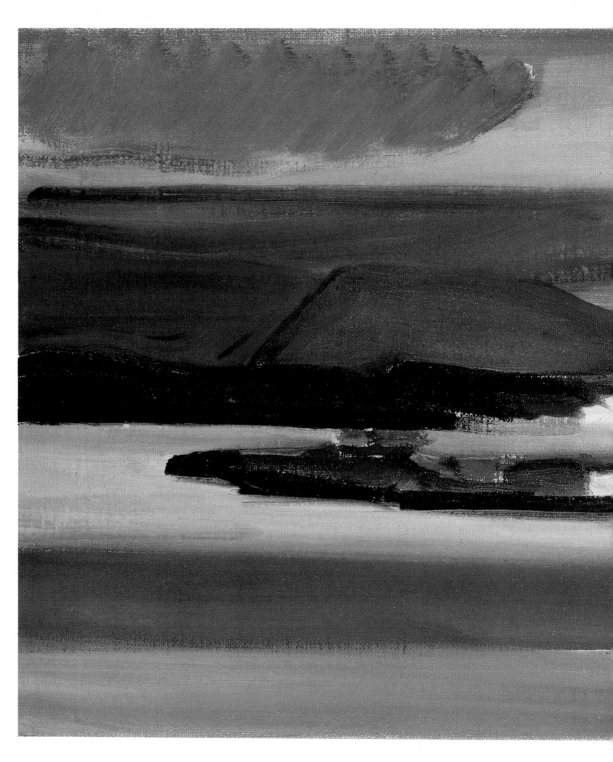

PLATE 22 | VIEW FROM HVERFISGATA 1984

oil on canvas 10 × 21 inches

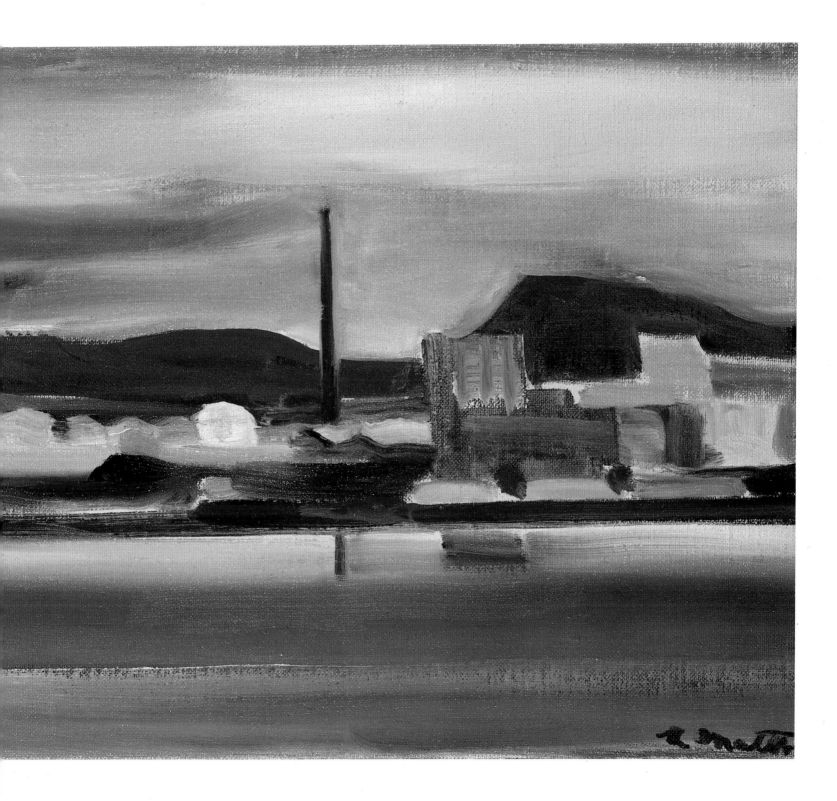

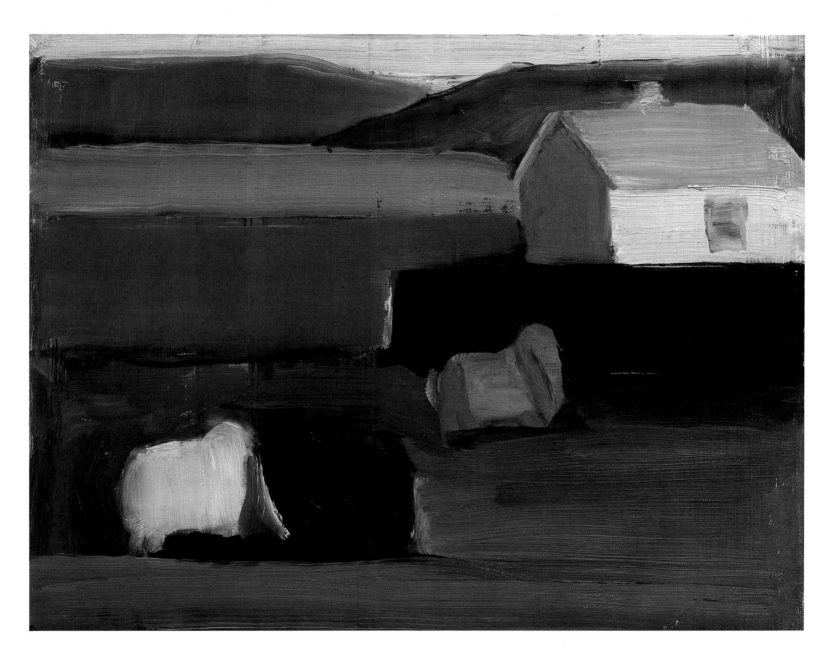

PLATE 23 | SHEEP AND WHITE HOUSE 1982

oil on canvas 9 × 12 inches

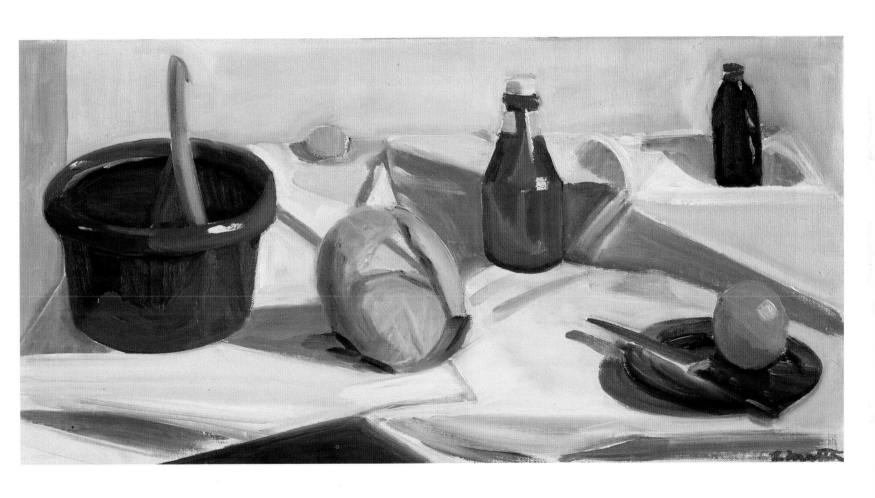

PLATE 24 | STILL LIFE WITH CABBAGE 1984

oil on canvas 13 × 26 inches

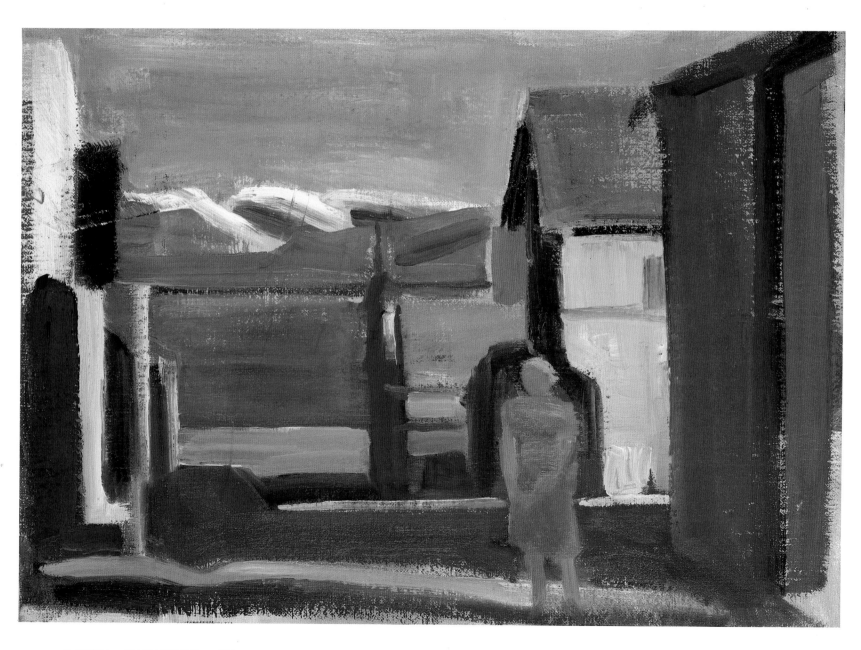

PLATE 25 | KLAPPARSTIGUR 1984
oil on canvas 12 × 17 inches

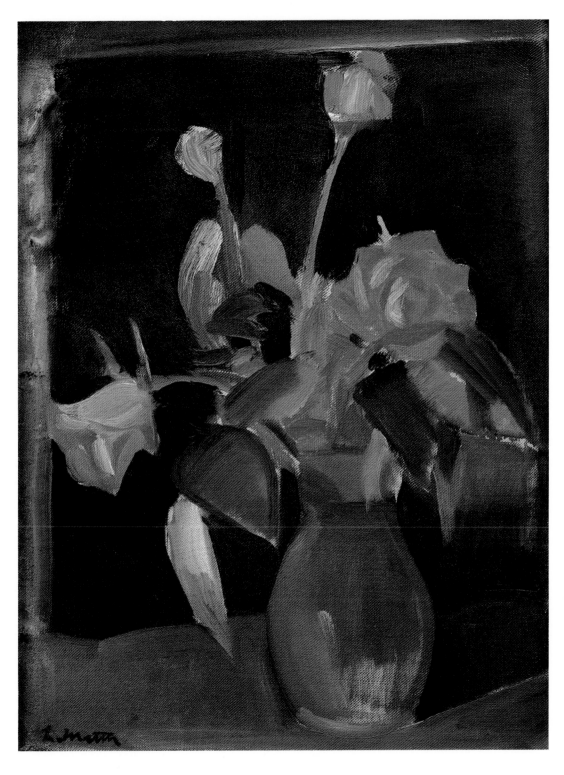

PLATE 26 | ROSES 1976

oil on canvas 14¾ × 11 inches

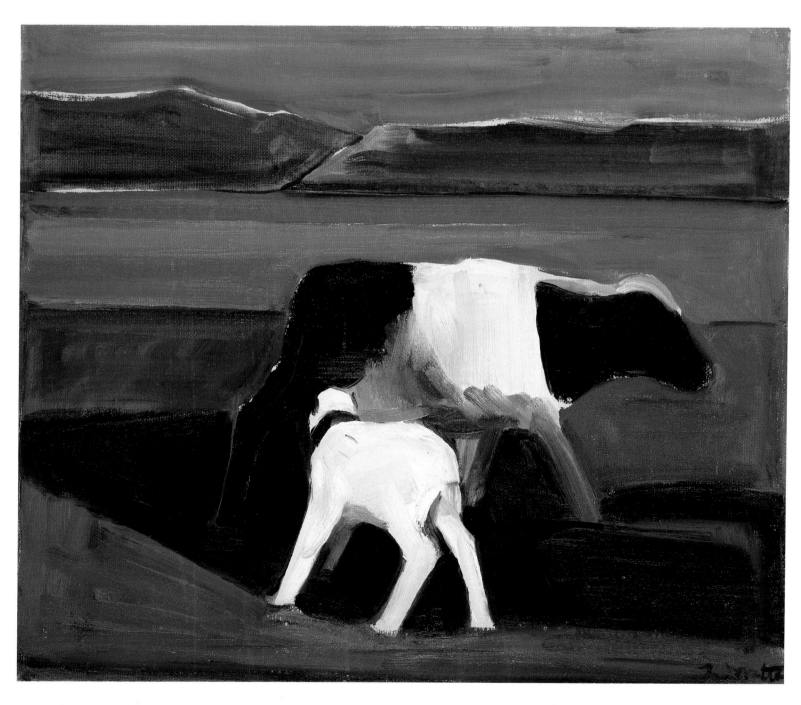

PLATE 27 | SHEEP AND LAMB 1984

oil on canvas 14 × 17 inches

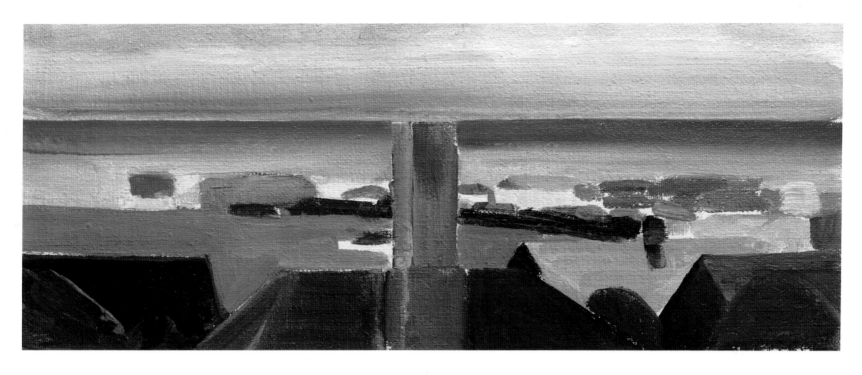

PLATE 28 | REYKJAVIK CHIMNEY 1980
 oil on canvas 5¾ × 15 inches

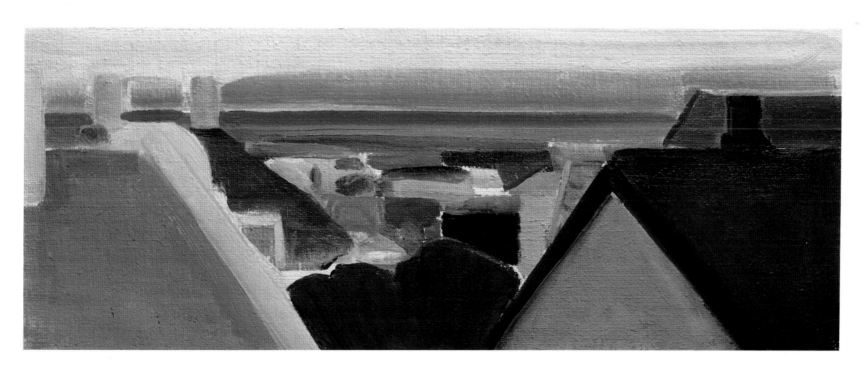

PLATE 29 | REYKJAVIK ROOFS 1980
 oil on canvas 5½ × 14½ inches

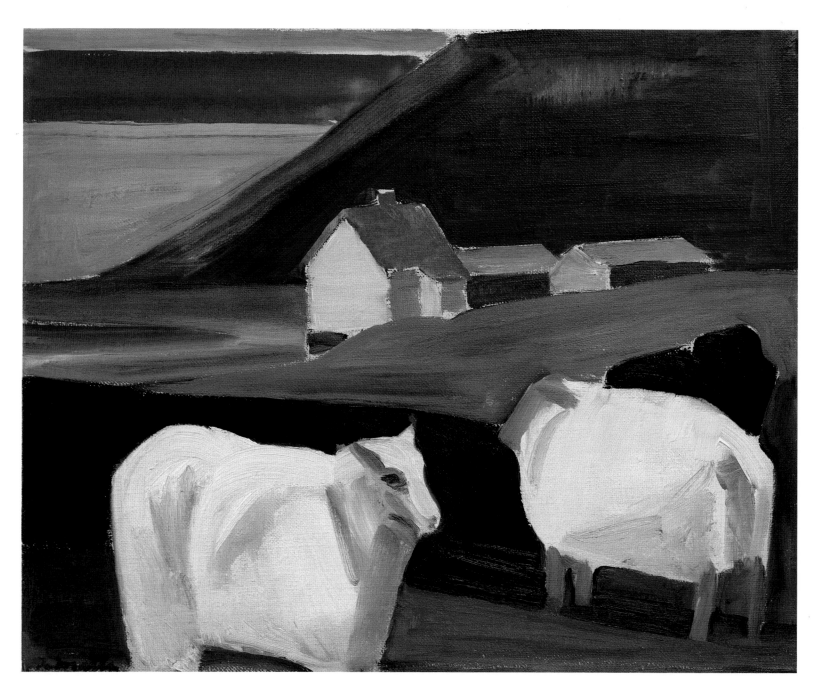

PLATE 30 | SHEEP AND YELLOW HOUSE 1983

oil on canvas 13 × 16 inches

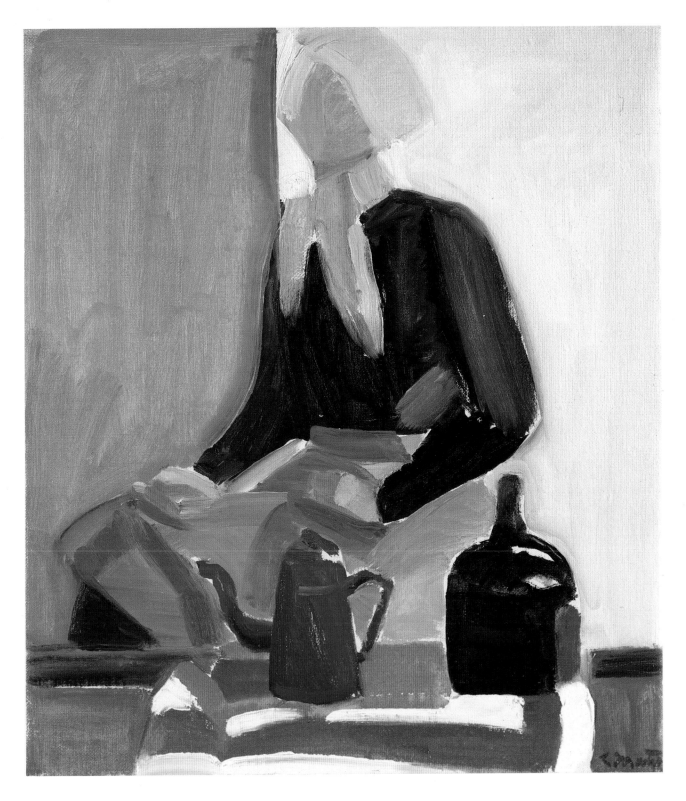

PLATE 31 | SELF-PORTRAIT WITH COFFEE POT 1980

oil on canvas 16 × 14 inches

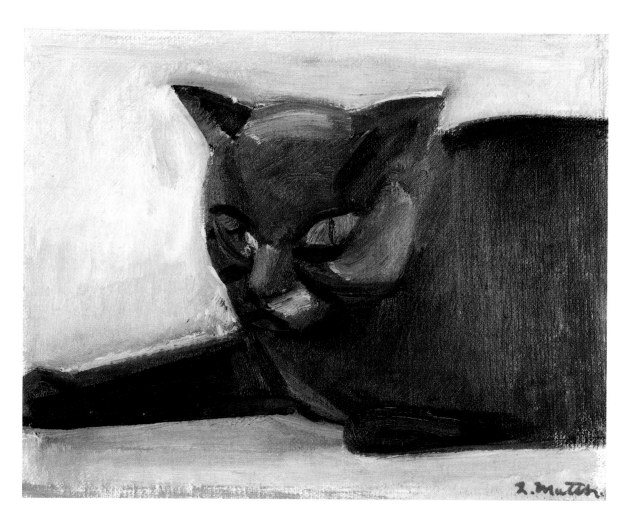

PLATE 32 | KISA 1978

oil on canvas 8 × 10¾ inches

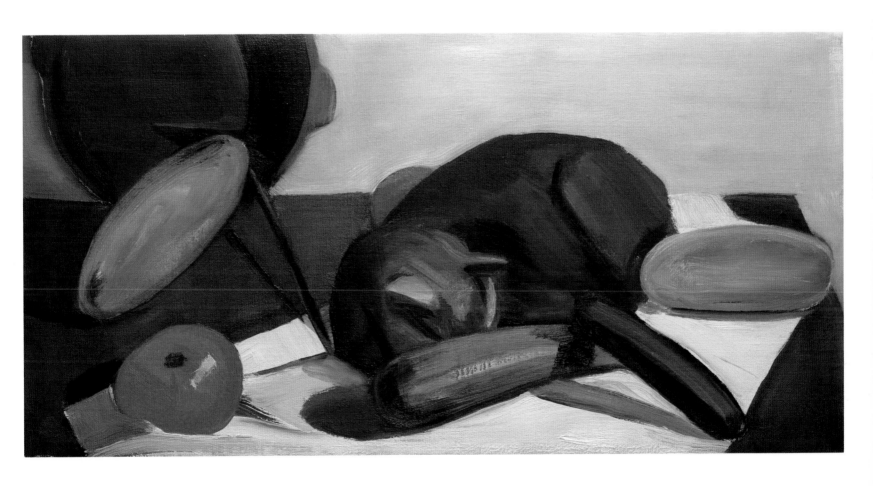

PLATE 33 | CAT AMONG VEGETABLES 1984

oil on canvas 12¾ × 25¼ inches

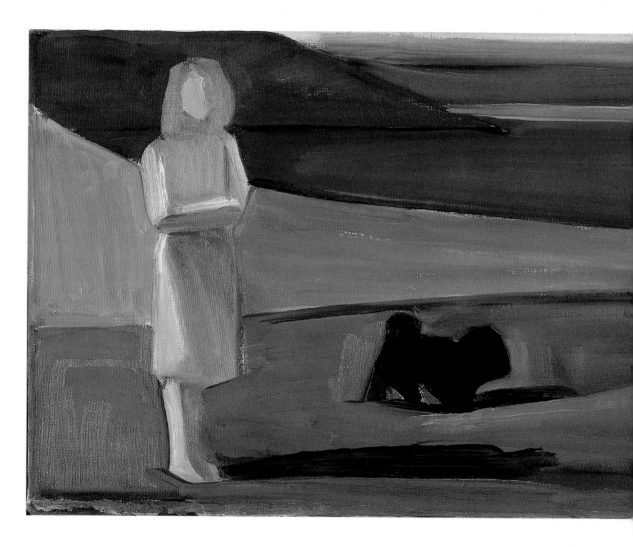

PLATE 34 | GIRL WITH HORSE AND DOG 1984
oil on canvas 11 × 34 inches

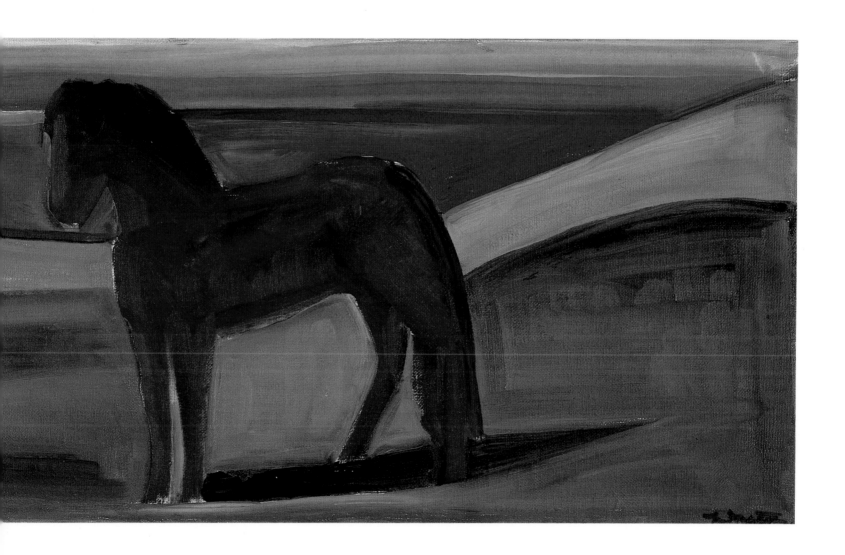

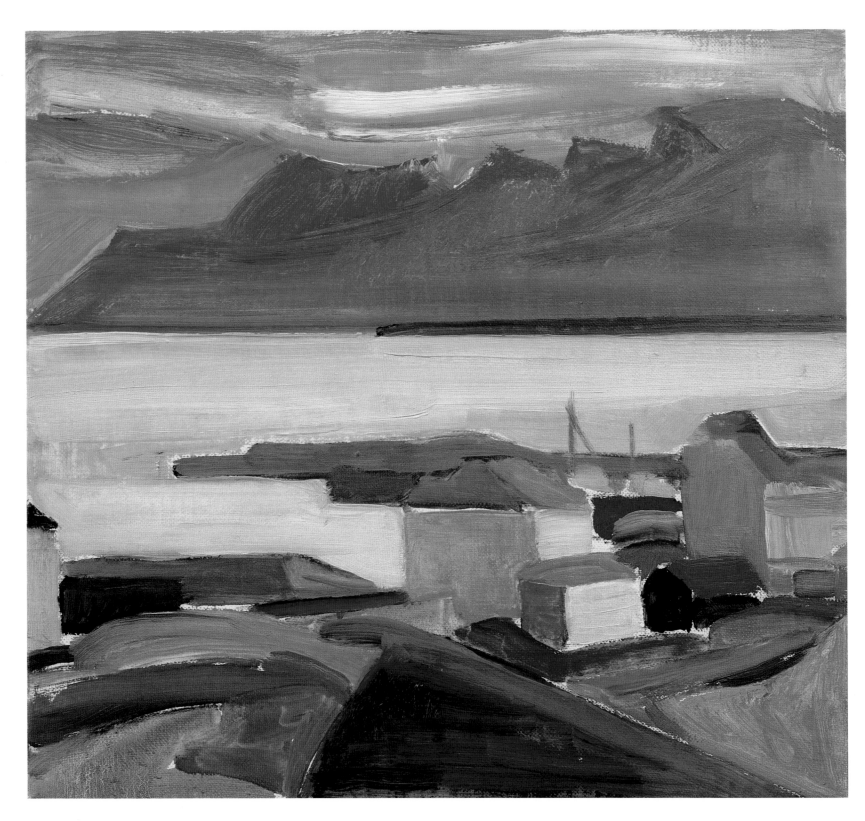

PLATE 35 | OLAFSVIK 1978

oil on canvas 11 × 12 inches

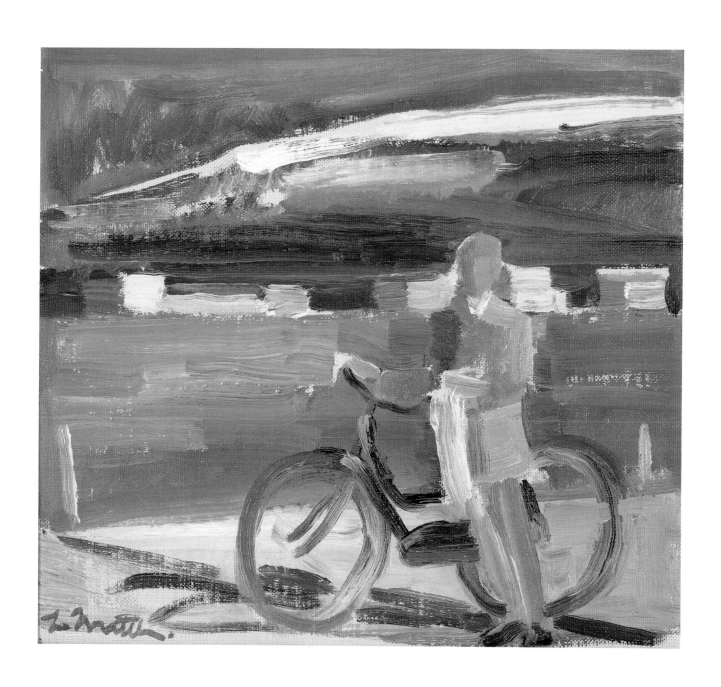

PLATE 36 | GIRL WITH BICYCLE 1972

oil on canvas 9 × 10 inches

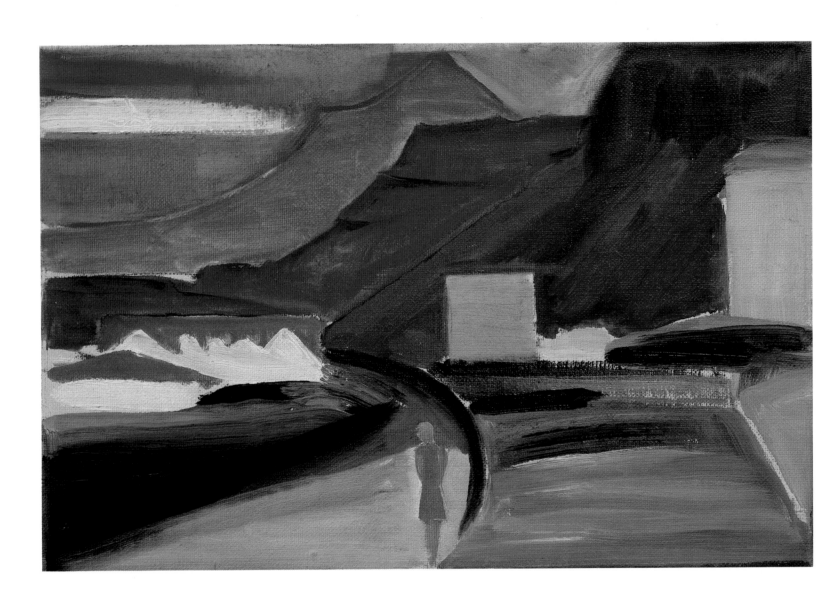

PLATE 37 | LANDSCAPE WITH FIGURE 1983

 oil on canvas 9 × 14 inches

46

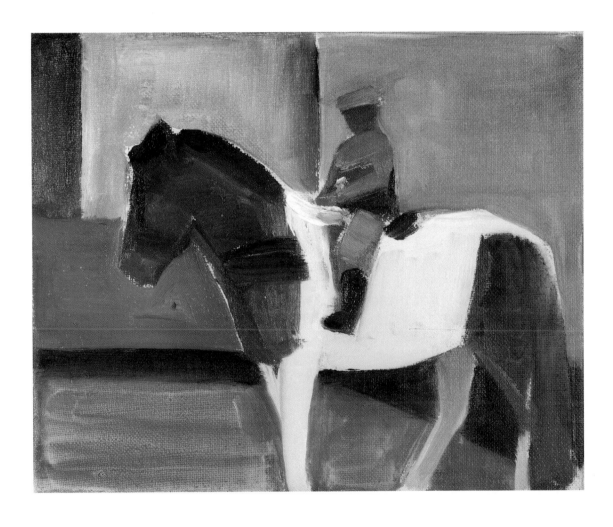

PLATE 38 | MATTI ON HORSEBACK 1980

oil on canvas 8 × 10 inches

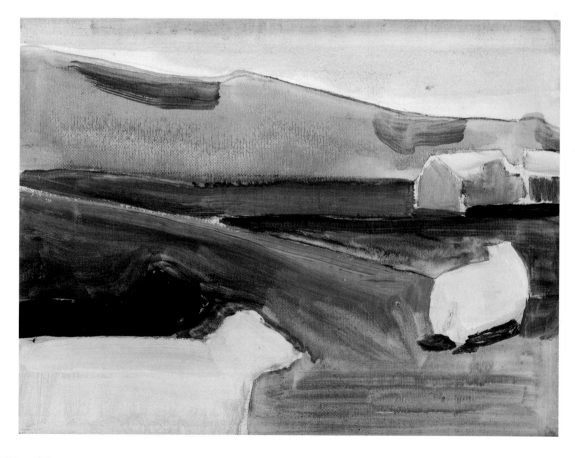

PLATE 39 | SHEEP AND ORANGE HOUSE 1980
oil on canvas 8 × 11 inches

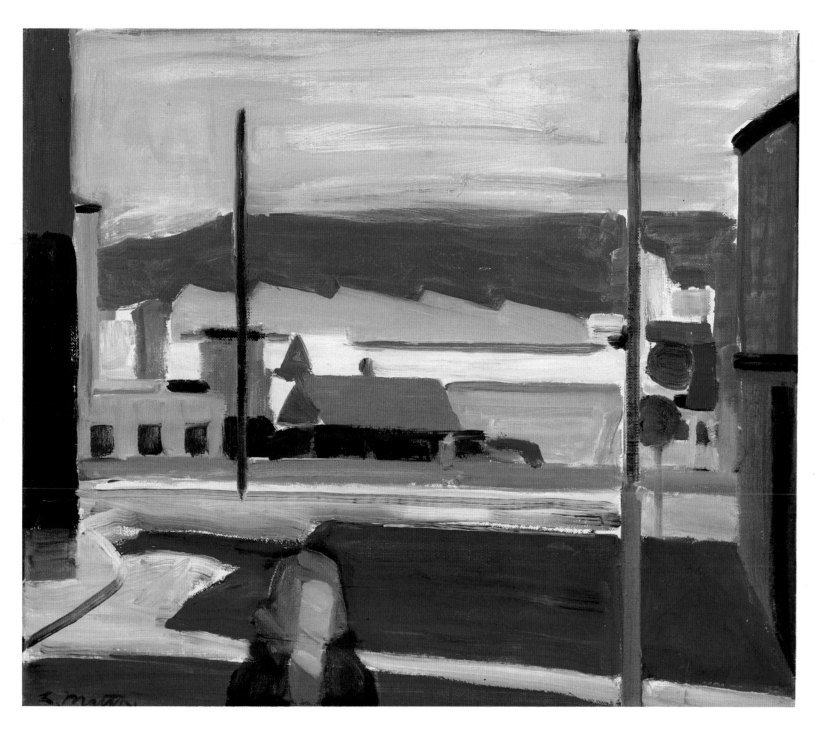

PLATE 40 | VESTURGATA 1980

oil on canvas 14 × 16½ inches

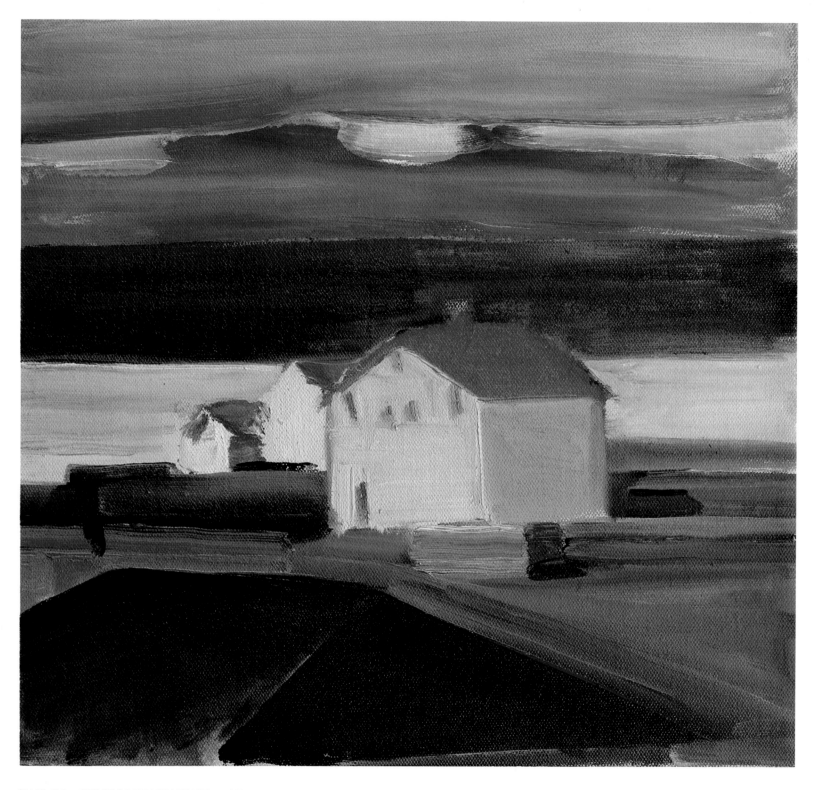

PLATE 41 | RED ROOF, YELLOW HOUSE 1982

oil on canvas 10 × 11 inches

With an eye made quiet by the power
Of harmony, and the deep power of joy,
We see into the life of things.

WILLIAM WORDSWORTH, *Tintern Abbey*

Nicholas Fox Weber

THE SMALL PAINTINGS of Louisa Matthiasdottir reveal visual and human glories with an intensity and brilliance that belie their scale. Like small children at their best moments, these canvases and watercolors fill us not only with their charm and freshness, but with their beguiling complexity. Just as babies are smaller than adults but have, in miniature, every vein and muscle that makes the system work, these paintings, complete and dynamic, leave us in want of nothing.

Matthiasdottir painted most of them, in fact, after she had completed related large paintings—almost like plot synopses. Unlike many artists' small works, they are not preliminary sketches or studies—but then, the working-out process never really shows in her work. Louisa Matthiasdottir is one of those rare natural artists: a painter who is able to transmit her warm vision of the world, at once calm and euphoric, through paint on canvas or paper with an apparent ease and effortlessness that are in no way primitive or unconscious. Spontaneously, with intrinsic grace, she makes rhythmic, balanced compositions that evoke, for the most part, her native Iceland: its clear, piercing light, its vigorous citizens, healthy livestock, and crisply defined landscape. The warmth and energy that emanate from these paintings reveal the extent to which the streams and farms of the Icelandic countryside and the streets of Reykjavik fill her with an unsullied pleasure. They express the wholeness and seren-ity that we may, as adults, continue to derive from the sights that first transported us in childhood, and that prompted Wordsworth to write on the banks of the Wye,

Again I hear
These waters, rolling from their mountain-springs
With a soft inland murmur. Once again
Do I behold these steep and lofty cliffs,
That on a wild, secluded scene impress
Thoughts of more deep seclusion; and connect
The landscape with the quiet of the sky.

Like Wordsworth's lines, Matthiasdottir's paintings are evocation, not reminiscence. There is no tortured reconstruction of an elusive past, but, rather, a pleasure first known long ago, brought forward as a present, completely accessible delight.

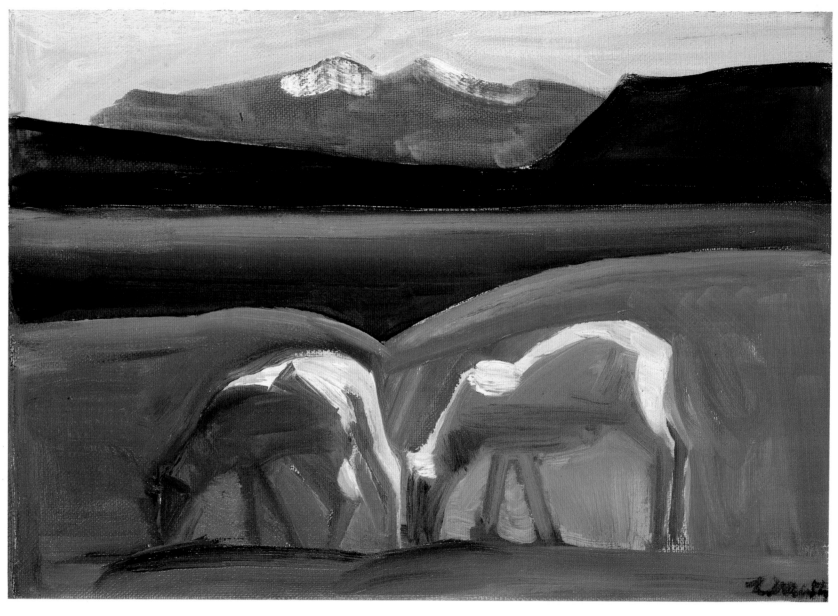

PLATE 42 | TWO SHEEP, YELLOW SKY 1984
oil on canvas 9 × 13 inches

These little gems of paintings are celebrations. With a total openness—without thought of a trick or gimmick or artistic "device"—they evoke a robust and simple beauty. They are at once about living and about painting. A golden sunrise, all the sharper in that clear, northern Icelandic light, glows behind snowy peaks and a deep blue lake as it casts its radiance on sheep feeding in a lush pasture. The sunlight per-

meates the grass and enriches it. Fishermen dock their boats and take in their good catch at the end of a peaceful day as a tranquil purple sky closes in on calm water. The vigorous figures, whether family groups on an outing in the countryside or women shopping in the city, are competent and capable. And throughout it all brushstrokes are powerful and sure, precisely making shadows or establishing water while being honestly, ecstatically paint. We feel the artists's distinct pleasure in the use of the loaded brush to evoke energy and vitality, and in the tactile character of oil paint and the soft translucence of watercolor.

The figures in these paintings are almost always in the foreground. We know exactly where they stand, both in the psychological hierarchy of the artist's mind and within the three-dimensional composition she has made for us. The colors and forms are organized with unerring precision; the spaces recede flawlessly. The scenes are full of air and palpably resemble the real outdoors. There is often a horizon line, and then a landscape of mountains or buildings and sky that rises from it, in scale and with the correct hue and light intensity for its position in space.

In their particular colors, their energy and flow, and the intricate rhythms of the figure groupings, these paintings are the products of deep warmth and generosity and a highly personal vision and skill. They are complete entities, giving us the sense that we are seeing everything there is to be seen of the chosen subject. They recapture and share with us pleasures the artist has long known, and that have long sustained her. But they do more than this. They invent a new form of beauty, and fill us with its power.

These beauteous forms,
Through a long absence, have not been to me
As is a landscape to a blind man's eye;
But oft, in lonely rooms, and 'mid the din
Of towns and cities, I have owed to them
In hours of weariness, sensations sweet,
Felt in the blood, and felt along the heart;
And passing even into my purer mind,
With tranquil restoration—feelings too
Of unremembered pleasure; such, perhaps,
As have no slight or trivial influence
On that best portion of a good man's life,
His little, nameless, unremembered acts
Of kindness and of love.

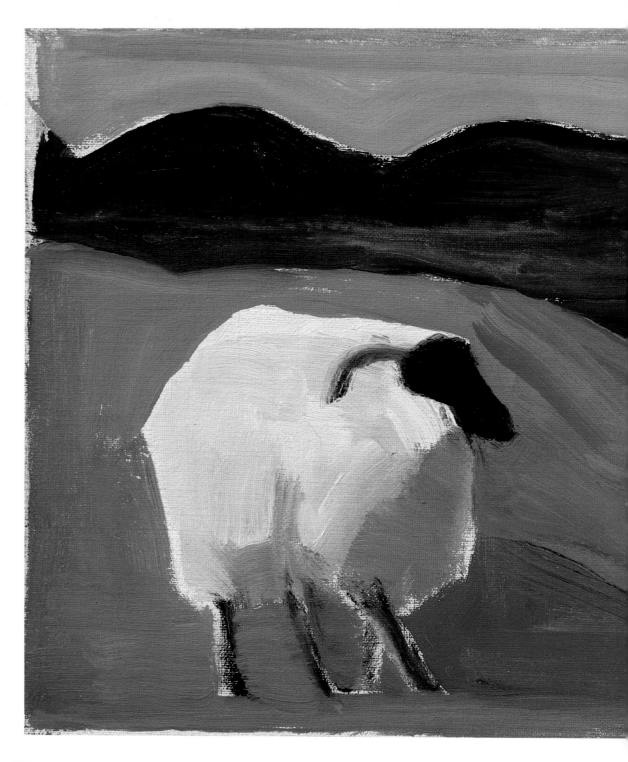

PLATE 43 | SHEEP AND MOUNTAIN 1985
oil on canvas 9¼ × 19½ inches

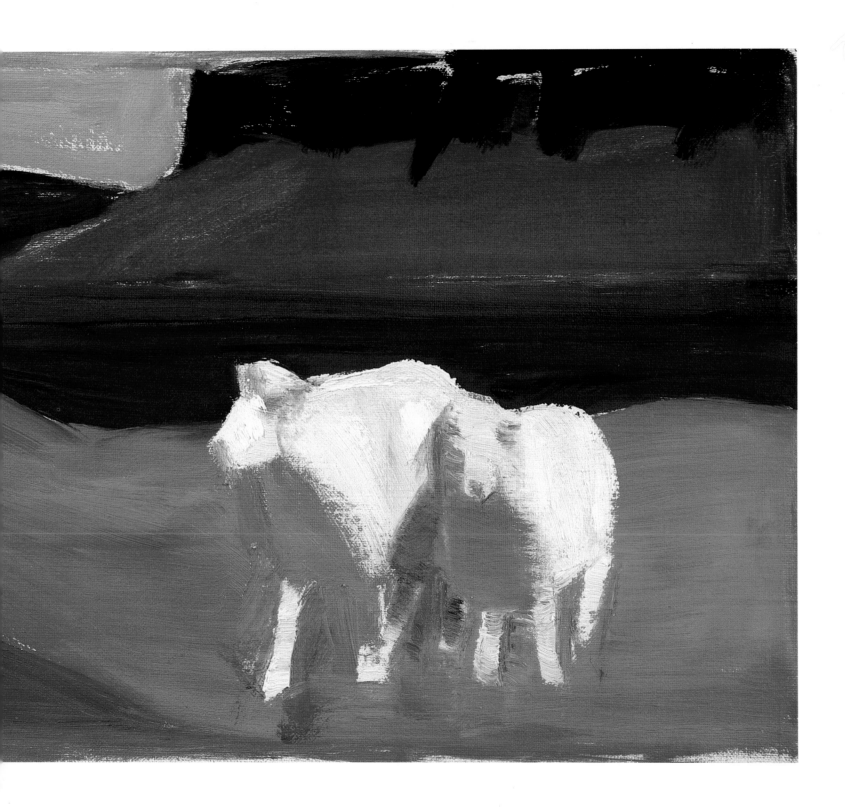

EXHIBITIONS

SELECTED TWO-MAN AND GROUP

1963 Manhattanville College, Riverdale, New York (with Leland Bell)
"Five American Realists," Knoedler Gallery, New York City

1964 Indiana University, Bloomington (with Leland Bell)

1966 Kansas City Art Institute, Missouri (with Leland Bell)
Procter Art Gallery, Bard College, Annandale-on-Hudson, New York (with Leland Bell)

1967 Austin Art Center, Trinity College, Hartford, Connecticut (with Leland Bell)
"Painting and Sculpture Today," John Herron Art Museum, Indianapolis, Indiana

1972 Swain School of Art, New Bedford, Massachusetts (with Leland Bell)

1973 "A Family of Painters," Canton Art Institute, Canton, Ohio
(with Leland and Temma Bell)
Biennial Exhibition, Whitney Museum of American Art, New York City

1974 Haustsyning F. I. M., Reykjavik, Iceland

1975 "Painterly Representation," Ingber Gallery, New York City

1978 "Drawing and Painting on Paper," Kemper Gallery, Kansas City Art Institute, Missouri

1981–82 "Contemporary American Realism Since 1960"
Pennsylvania Academy of Fine Arts, Philadelphia
Virginia Museum of Fine Arts, Richmond
Oakland Museum, California

1982 "Perspectives on Contemporary Realism: Works on Paper from the Collection of
Jalane and Richard Davidson"
Pennsylvania Academy of Fine Arts, Philadelphia
Art Institute of Chicago, Illinois

1983 "American Still Life Painting, 1945–1963," Contemporary Arts Museum, Houston, Texas

1984 "New Vistas—Contemporary American Landscapes,"
Hudson River Museum, Yonkers, New York
"American Art Today: Still Life,"
Visual Arts Gallery, Florida International University, Miami
"Nine Realists Revisited, 1963–1984," Robert Schoelkopf Gallery, New York City
"10 Gestir Listahatidar 84," Reykjavik, Iceland

COLLECTIONS

Ashbery, John | NORTH LIGHT.
 Art News, February 1972.

———— | METAPHYSICAL OVERTONES
 New York Magazine, 11 February 1980.

———— | LOUISA MATTHIASDOTTIR
 Essay in exhibition catalogue, Robert Schoelkopf Gallery, 27 January 1982.

Austin Art Center, Trinity College | LELAND BELL, LOUISA MATTHIASDOTTIR.
 Exhibition catalogue, 1969.

Bass, Ruth Gilbert | FIVE REALIST PAINTERS.
 Ph.D. diss., New York University, 1978.

Campbell, Lawrence | LELAND BELL, LOUISA MATTHIASDOTTIR, TEMMA BELL: A FAMILY OF PAINTERS.
 Introduction to exhibition catalogue. Canton Art Institute, 1973.

Hobhouse, Janet | INDEPENDENT ICELANDER.
 Quest, April 1979.

Ingolfsson, Adalsteinn | HLIDSTAEDUR VERULEIKANS.
 Lesbok, Morgunbladsins, Reykjavik, 9 June 1984.

———— | A SOLID AND SERENE WORLD.
 Iceland Review 3, 1984.

Johannessen, Matthias | MALVERK KEMUR EKKI I STADINN FYRI LIFID.
 Stord 1, 1984.

Kramer, Hilton | THE ART OF PAINTING IS ALIVE AND WELL.
 New York Times, 23 January 1976.

Perl, Jed | THE LIFE OF THE OBJECT; STILL LIFE PAINTING TODAY.
 Journal of the Artists' Choice Museum, Fall 1982.

Perl, Jed, and Deborah Rosenthal | LOUISA MATTHIASDOTTIR.
 Arts, April 1976.

Rand, Harry | LOUISA MATTHIASDOTTIR.
 Arts, April 1978.

Rosenthal, Deborah | LOUISA MATTHIASDOTTIR AT ROBERT SCHOELKOPF.
 Art in America, November 1984.

Sawin, Martica | LOUISA MATTHIASDOTTIR: A PAINTER OF THE FIGURE.
 Arts, November 1961.

Strand, Mark | *Art of the Real: Nine American Figurative Painters.*
 New York: Clarkson N. Potter, 1983.

Tallmer, Jerry | THE DOCTOR'S DAUGHTER: HER ART IS IN THE STILLNESS.
 New York Post, 9 January 1982.

BIOGRAPHICAL NOTES

Louisa Matthiasdottir was born in 1917 in Reykjavik, Iceland. She studied in Denmark and with Marcel Gromaire in Paris. She came to New York City in 1943, where she studied with Hans Hofmann. She currently divides her time between studios in Reykjavik and New York City.

Jed Perl and Deborah Rosenthal live and work in New York City. Mr. Perl is a regular contributor to *The New Criterion*, and has written for *Arts*, *Aperture*, and *Art in America*. He received an Ingram Merrill Award for Painting in 1982 and teaches at the Parsons School of Design. Ms. Rosenthal shows her paintings at the Bowery Gallery. She has taught painting at the Kansas City Art Institute and currently teaches at Parsons and the School of Visual Arts. In 1980 she received a critic's grant from the National Endowment for the Arts for her articles in *Arts* and *Artforum*.

Nicholas Fox Weber is author of *The Drawings of Josef Albers* (New Haven: Yale University Press, 1984) and the forthcoming *Leland Bell* (New York: Hudson Hills Press, 1986). He has curated exhibitions, lectured, and written catalogues and articles on various aspects of twentieth-century art.